FRANCIS HO

F R A N C I S H O

DUALITIES

Washington State University Press
Pullman, Washington

WSU PRESS ART SERIES

Francis Ho: Dualities (1991)
Andrew L. Hofmeister: Odyssey (1991)
Gaylen Hansen: The Paintings of a Decade, 1975-1985 (1985)
Fabric Traditions of Indonesia (1984)

Washington State University Press, Pullman, Washington 99164-5910
Copyright 1991 by the Board of Regents of Washington State University
All rights reserved
Printed and bound in the United States of America
ISBN 0-87422-083-1 (hardbound)
ISBN 0-87422-082-3 (paperback)

Cover: *Pacific Coast Series #2: Banyan tree, 1988*

TABLE OF CONTENTS

Foreword...1

Dualities...3

The Gestalt of Perception...9

Chronology/Biography...62

For Anne, Harry, Jan, & Elsie

Acknowledgements

I am grateful to Dr. Mary Stieglitz Witte for her wonderful essay and the enthusiasm she has shown throughout the project. Warm thanks likewise to Rod Slemmons for his insightfulness and clarity in interpreting my work. Special thanks to John Stamets, who came from Seattle and miraculously managed to get me to relax in front of his lens. Much thanks to Dr. Geoffrey Gamble and his staff at the WSU Department of Anthropology for generously providing darkroom facilities where I printed the pieces for this book.

Also, appreciation goes to my dear sister, Muriel Lai, who has given me constant encouragement. Thanks to my sons, Marshall and John, and step-sons, Adam and Matthew, for sharing their activities with me and providing thoughtful ideas and a positive attitude about my photographs. Grateful thanks to Al Weber, my dear friend and mentor, whose critical honesty about my work is always accompanied with much gentleness and support. I also want to express my appreciation to my musical instructor, Dodi Dozier, and to Dan Fear of The Silver Image Gallery in Seattle, who represents me and keeps me abreast of regional photographic activities. Finally, I wish to thank all of my colleagues, students, and numerous other individuals who always supported me and who continue to teach me new ways of seeing. —F.H.

FOREWORD

by Rod Slemmons
Associate Curator of Photography
Seattle Art Museum

Photography is a medium driven by old conventions. Once a particular way of looking through the camera is found to provide a successful substitute for what is in front of the camera, it has a paralyzing effect on all subsequent photographers. We move the frame until the pieces fit the convention, and then freeze except for the index finger. This may be due to habit, however it is most certainly also due to the fact that recreating reality on a flat piece of paper is hard. It is easier left to somebody else's idea of how it should be done. Time, physical space, even the mood and sense of a place are all recreated by specific, well-known forms of design and photo-manipulation.

All of this is so familiar and expected that when a photographer like Francis Ho invents a new set of conventions and begins to run variations on it, we sit up and take notice. Old conventions that have become transparent with use suddenly become opaque in their absence, and we are, as if for the first time, returned to the knowledge that we are not looking through a window, but at a flat field of specifically chosen and ordered information. Then we get the great pleasure of moving into the picture from scratch—knowing how it works as well as what it is about.

In general—with all kinds of art—this is not easy. It is like trying to maintain involvement with fictional characters created by great actors while we observe and enjoy the sheer craft of acting. But if we can manage it, a new and rich pleasure is available to us. Ho has recombined some old conventions to help us. First, he uses the late nineteenth-century technology of the huge 11 X 14 inch camera, with its impossible,

hallucinogenic focus. Even if we were standing where he stood, we could not see so much detail simultaneously across our field of vision. Second, he combines two images from the same point of view: we look and then we look again in an automatic extension of our attention span.

Third, and most importantly, he stacks the two images so that our axis of examination is vertical rather than horizontal. As in the Chinese paintings of his ancestors, this up and down observation of the visible world is symbolic of moving from the simple to the profound in the poetic world—moving down through layers of meaning to knowledge. This contrasts with the horizontal accumulation of information on a single plane usually found in Western picture making. The marginal break between Ho's images makes us pause and contemplate the direction and goal of our journey.

Ho inextricably combines our experiences of a piece of the world that he would like us to observe with his specific observation guides. He is then free to improvise, using all of the tricks in his photographic bag. For example, he adds or removes details or slightly changes the angle of one of the images so he can line up repetitive structures in the landscape. Again, like many early Chinese painters, he likes to reveal the hand of the maker at work, leaving the equivalent of the rough edge of a brush stroke to remind us of how illusory and poetic the whole notion of a two dimensional representation is. After twenty years of carefully seeing through the camera, Ho has concluded and demonstrated that what is thought to be the most concrete and "realistic" of media is, ironically, best at abstract communication.

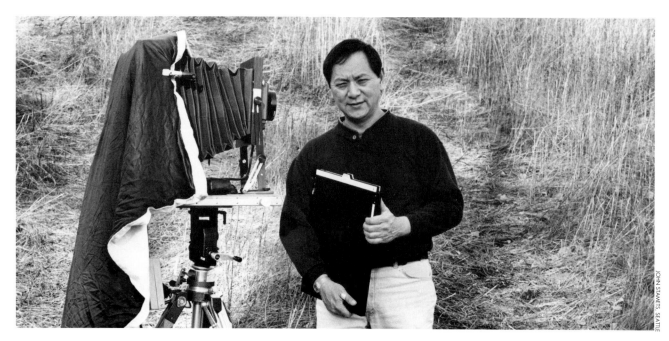

Francis Ho, November 1990.

JOHN STAMETS, SEATTLE

DUALITIES

by Mary Stieglitz Witte
Professor/Chair
Department of Art
Boise State University

Francis Ho embraces light in dual compositions arranged in vertical tandem. His diptychs, which reveal intentional patterns of unity as well as subtle dichotomies, ask the eye to accept two juxtaposed images as a singular form. Photography, which for more than 150 years has been considered a reliable vehicle for accurately portraying truth, becomes for Ho instead a way to challenge viewers with visual and perceptual riddles. His images embody Pablo Picasso's well-known statement, "Art is a lie that makes us realize the truth."

Landscapes are the subjects Ho uses to express his concepts about perception. They are oftentimes familiar places; the mountains, ocean, streams, and foliage of Hawaii are, for example, part of his heritage. When eight years old, he hiked to the top of Hawaii's Mt. Tantalus to earn a Boy Scout badge. The sea too was as much home to him as the land. Now, periodic trips back to Hawaii, along with regular visits to favorite places in the West and the Pacific Northwest, provide continual photographic resources.

In searching for answers to his many visual questions, new interpretations constantly arise for Ho. He does, in fact, prefer the questions to the answers.

Music stimulates his imagination while working in the field and sometimes it helps to provide a visual narrative. A tree, for instance, might become a person surrounded by other trees in various human-like postures. Jazz, with its improvised themes and ultimately resolved harmonic discords, reflects the rhythmic tension he seeks in his images.

Both Far Eastern and Western aesthetic ideas about "landscape" are clearly evident in Ho's pictures. As a child, he was intrigued by the wood-cut prints of the nineteenth-century Japanese master, Ando Hiroshige, and equally drawn to Chinese watercolor paintings of the Sung Dynasty (A.D. 960-1280). Their use of negative space compelled Ho to participate imaginatively in the interpretation of the artwork. Elements having little or no definition suggested visual depth, while detailed shapes provided clues regarding place.

Included in Hiroshige's *Ichigaya Hachiman Shrine*, dated 1858, is an important element of blank space between the top and bottom parts of the print. In this case, a band of clouds is the blank space. It creates a visual division, but at the same time integrates the parts into a whole. Similarly, Ho's diptychs serve to both divide and bind. Since they are purposefully misaligned or often overlapped, and in some cases even assembled from different locations, visual discord as well as harmony exist between them.

The work of pioneer Western photographers, Carleton E. Watkins (1829-1916) and Timothy O'Sullivan (1840-1882), also has influenced Ho. Watkins, one of the first landscape photographers, treated the medium and the subject with equal respect. His straightforward, well-balanced pictures of the land make an easy, rational transition from one plane to another in a true classical style. O'Sullivan, on the other hand, revered the vast wastelands of the West. His photographs opened up subject possibilities by demonstrating that ordinary terrain, if treated with intelligence and taste, could generate arresting photographs.

Watkins's and O'Sullivan's approach to photography is reflected in part in Francis Ho's vision. His subject has consistently been landscapes, even when photographing the nude as

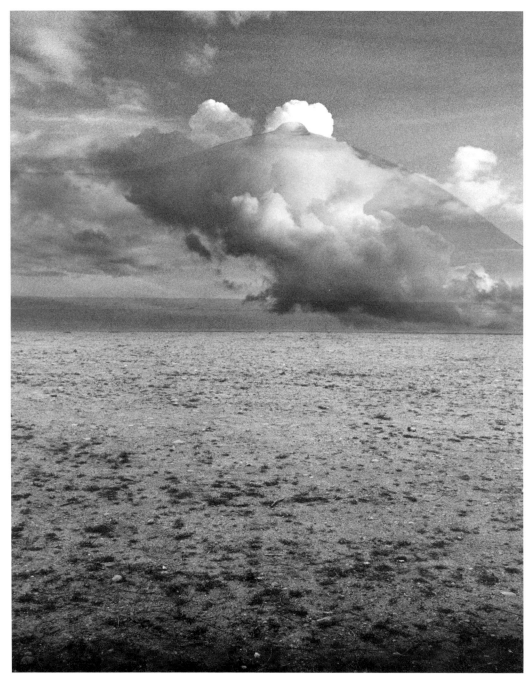

Francis Ho, *Hose Valley* (Hoensbroek, Holland: Drukkerij Rosbeek, 1975).

metaphor (*Hose Valley*, 1975). And, of course, his use of a large format view camera to make contact prints recalls the style and equipment of the nineteenth-century masters.

Ho's first camera was purchased for a photography class when he was studying graphic design at Yale. The course was specifically design oriented, emphasizing the interrelationship of form and other principles of the graphic arts curriculum. From that time on, Ho began perceiving his art both graphically and photographically.

Also while at Yale, he was introduced to the principles of psychology, which encouraged him to explore Gestalt ideas of perception (basically, the inherent tendency of the mind to organize various perceived elements into "wholes"). It was during this time too that Ho found a mentor in Bauhaus painter and teacher Josef Albers (1888-1976), whose Gestalt perceptions of line and color were influential in his development. These ideas continue to exert an influence on the composition and organization of Ho's work today.

After earning a Bachelor of Fine Arts degree in 1961, Ho served for two years as a Lieutenant in the 7th Infantry Division. An armored reconnaissance platoon leader, he was stationed in Korea, Japan, and California. Upon discharge, he returned to Massachusetts and New York to work in private practice and begin graduate studies. On completing a Master of Fine Arts degree at the Rochester Institute of Technology in 1967, Ho came to Washington State University, Pullman, to teach graphic design. At that time, the Fine Arts Department had yet to offer photography classes. Ho was given the opportunity to introduce these courses and thus began his career-long dedication to teaching photography at WSU.

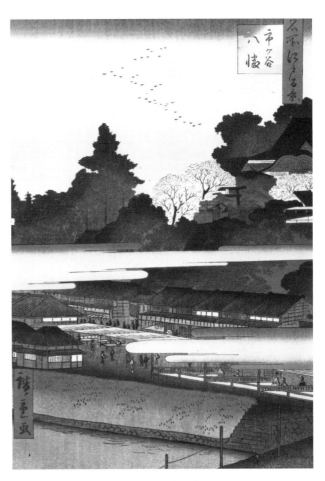

Ichigaya Hachiman Shrine, **by the master Japanese printmaker Ando Hiroshige (1797-1858). This 1858 woodcut is one of Hiroshige's widely known "100 Views of Edo."**

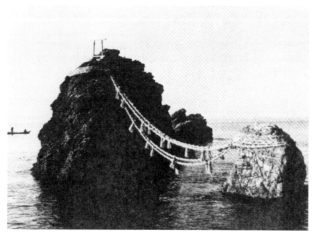

Meoto-iwa, or the "wedded rocks," located offshore
from Ise-Shima National Park, in the Sea of Japan.
"I liken my pairing of images to these two rocks tied
together with a rope; in effect joined, yet separate
entities." —F.H.

Ho works exclusively with a Deardorff field
view camera. His choice of format produces 11
X 14 inch negatives with which he makes contact
prints. He considers the camera to be a simple
tool that allows images to be made in a straight-
forward manner. Working with gear that weighs
nearly 100 pounds clearly affects how and where
he works—most of the time not too far from a
car. He uses only a 360mm Nikkor-W lens with
an attached electronic shutter, thus allowing
complete mechanical control while behind the
camera and eliminating the need for an assistant.

Setting up the Deardorff is a carefully calcu-
lated decision because of the time and effort
involved in preparing it for shooting. Ho has to
do a lot of looking and considering, often mov-
ing away from, and returning to, a location
before actually deciding on where and when to
set up. The quality of light—natural, transient—
is a major consideration.

Seeing the image as it appears in the view

camera upside down forces the eye to concen-
trate completely on the scene, and the grid
etched on the ground glass allows Ho to com-
pose images precisely. His background in graphic
design is ideal for this working method.

Once the decision is made to shoot, it can take
an entire day to produce a maximum of ten ex-
posures (which are contained in five film hold-
ers, with two film sheets each). The images are
composed in the eye and mind long before the
shutter clicks.

In describing the moment, Ho says, "Occasion-
ally the act of tripping the shutter produces a
tingle of excitement down my spine to my toes!
Of course, all of it can disappear at any stage. Ex-
posure error, light leaks from a faulty film holder,
scratches on the negative during processing, and
dropping a mounted print are only some of the
disasters that can happen."

Over the years, Ho has progressed from a
35mm camera, to a 2 and 1/4 square format, fol-
lowed by an 8 X 10 inch format, and finally to the
11 X 14 inch Deardorff.

He states humorously, "I believe the reason for
my move from 35mm to 11 X 14 stems from my
progressive nearsightedness. Also, I find more
pleasure working in the weather and light of the
outdoors than in the darkroom. Enlargements
from small negatives no longer hold much ap-
peal to me for the kind of images I now make,
although I have not ruled out the possibility of
returning to smaller formats. Presently, I am
attracted to the amount of clarity and visual
information that an 11 X 14 inch contact print
retains, and it can be read from a greater distance
with a better degree of clarity than equivalent
sized enlargements of smaller formats."

He goes on to say, "Technical competence is

 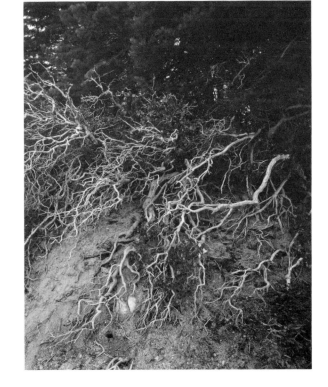

Tahoe, 1984; the genesis of Ho's diptych series.

what I believe almost anyone can achieve with practice, but the real challenge is found in that which produces visual conceptual consistency."

Some time ago, Ho asked Hiro (1931-), the celebrated New York fashion/commercial photographer whose work he admires because it addresses current and future cultural and global concerns, "How many photographs do you make in a year?" Much to Ho's surprise, Hiro replied, "Maybe, one."

Relative to Hiro's answer, Ho likewise feels that he rarely produces a photograph which successfully satisfies his goals. Regardless, he continues to persist in creating and resolving visual challenges while making elegant statements in black and white.

THE GESTALT OF PERCEPTION

THE GESTALT OF PERCEPTION

Jan rowed our dog Buck across the Lochsa River in Idaho to enjoy the late afternoon sun on Sunday, August 24, 1986

"To capture this scene, I set up on a ledge and shot down into the water. Here, composition and dark/light contrasts are the key; the solid mass of rock above my wife and our dog Buck, the water going past, and the sand bar in the middle. Seemingly simple in form at first glance, yet when you look it is quite complex."

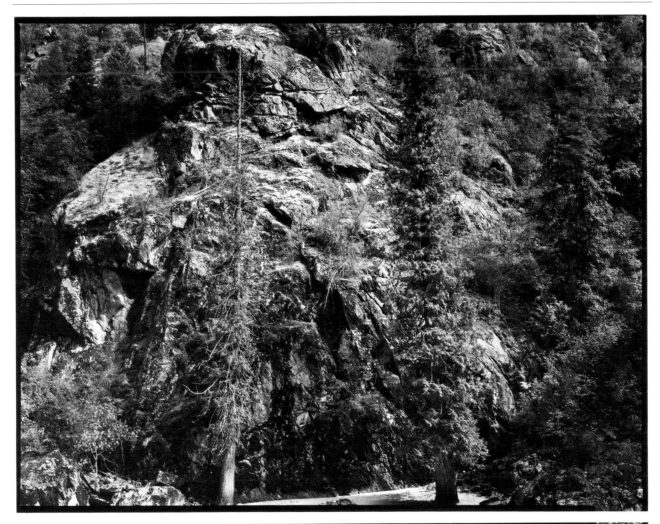

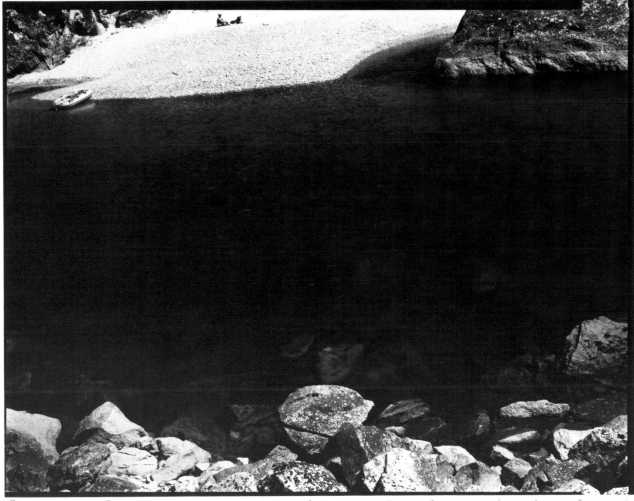

We thought—in fifteen or so years from now, it would be wonderful to us if we were granted the ability to perform the remainder of our life's work here in Alsea Heights, located near the town of Waldport, Oregon: what an idyllic notion it all seemed on Sunday morning, August 17, 1986

"We both felt very good in this area. The title describes a fantasy, our dream. This is a document of that dream. In 1988, we bought a plot of land in this same area to nurture our fantasy."

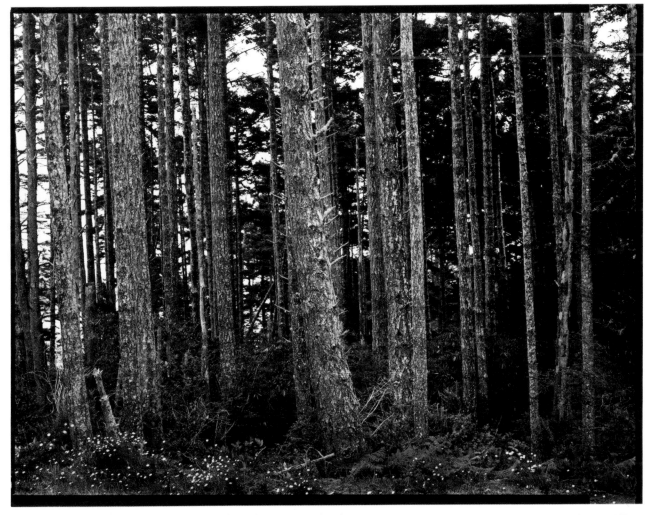

Francis Ho 1986

Jan reading while two veteran sport fishermen carry on mostly about the fog and lousy fishing conditions at Agate Beach, Oregon, on Monday morning, August 18, 1986

"I thought that if I did not mention Jan in the title of the photograph, she would go unnoticed. The sun bleached stump makes a powerful image, like the bones of some great sea creature washed ashore. I find both serenity and strong activity in this image."

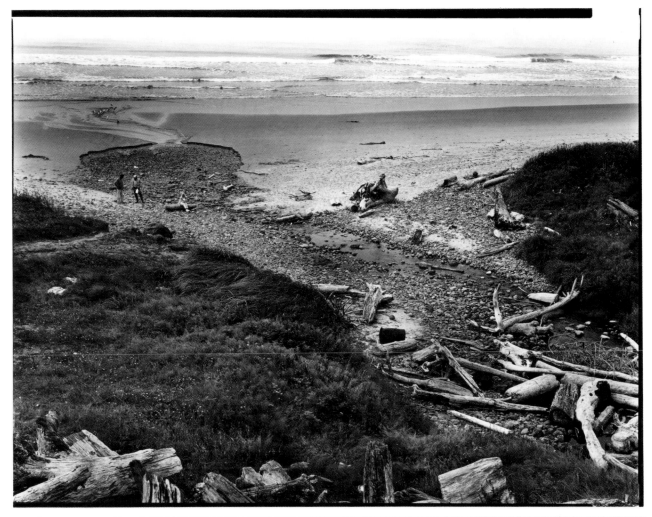

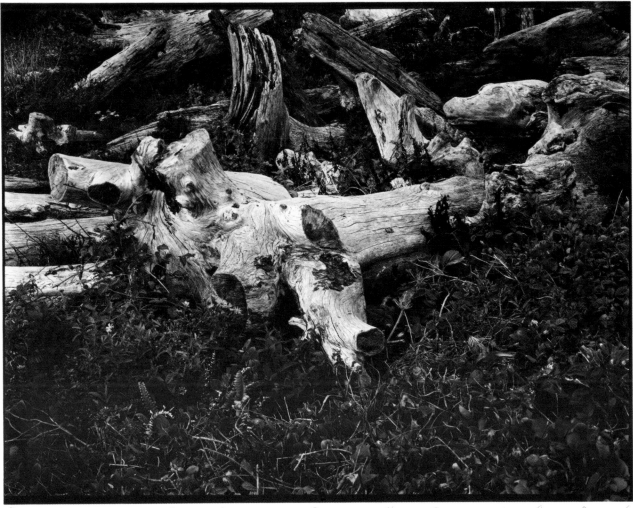

Pacific Coast Series #6, 1988

"When I looked at this Banyan trunk, it appeared to have human-like limbs. I composed this image, extended it, and balanced it to produce a tangle of limbs. For me, the quality of light heightened the drama of the composition."

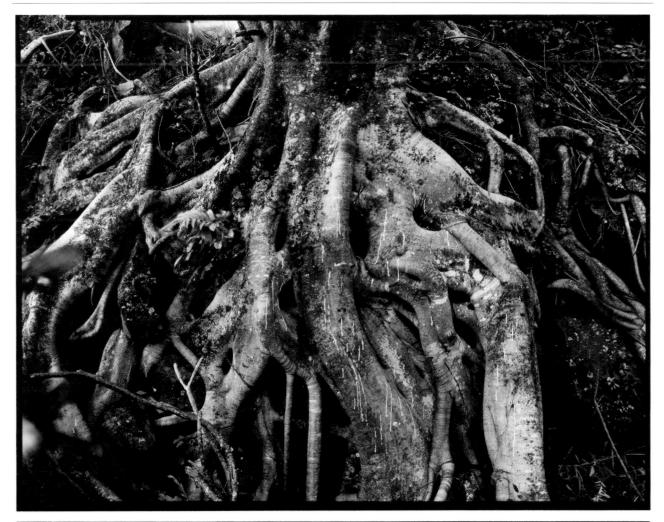

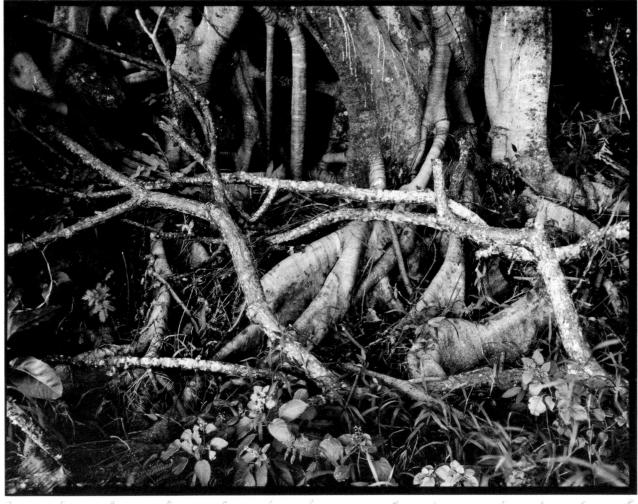

Pacific Coast Series #2: Banyan tree, 1988

"While visiting my parents in Honolulu, I would go up to Tantalus Mountain—one of the few places on the island relatively unpopulated and 'non-touristy'—where some of the Hawaii I knew remains intact. I looked around for views reminding me of my childhood. I happened by this particular spot; it was just there, an aura. Here, I visually split the limbs, which are the dominant element causing tension and bonding between the images."

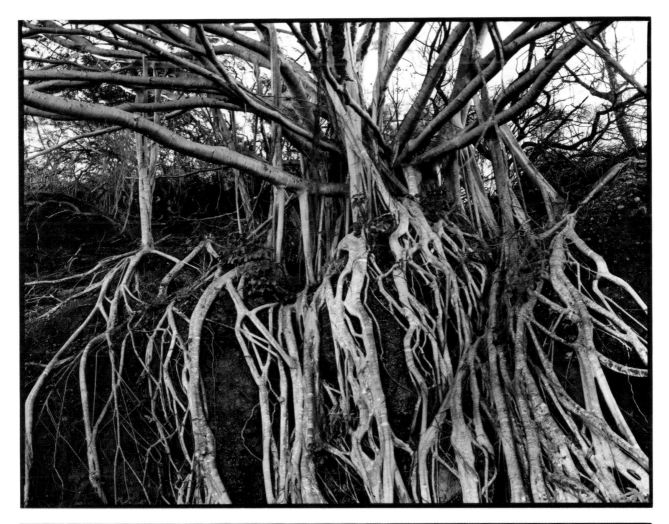

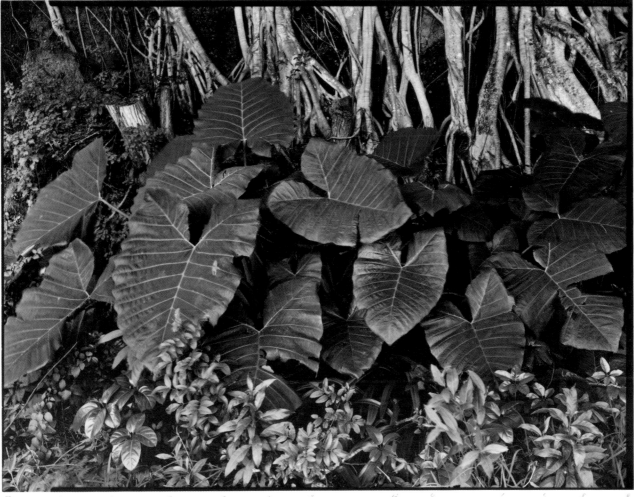

Bamboo forest, Tantalus Mountain in January, 1988

"Light was filtering through, the bamboo swayed and creaked—a wonderful sound. Liking the quality of the light, I wanted to capture the movement and maybe even suggest the sound of the creaking bamboo. When I was young, a bamboo grove was located across the street from my grandparents' home. When the wind blew, the grove made a dry, resonant, music-like sound. When the breeze was especially strong, the rubbing and clanking of wood to wood made a beautiful, delicate noise with percussive accents—a 'sensory memory' from my childhood.

"Bamboo was depicted in many of the woodblock prints by Hiroshige and other ninteenth-century Japanese artists. It is a utilitarian material used in building and for many other purposes. There is an expression, 'When the wind blows, bend like the bamboo, then straighten up when the wind passes.'"

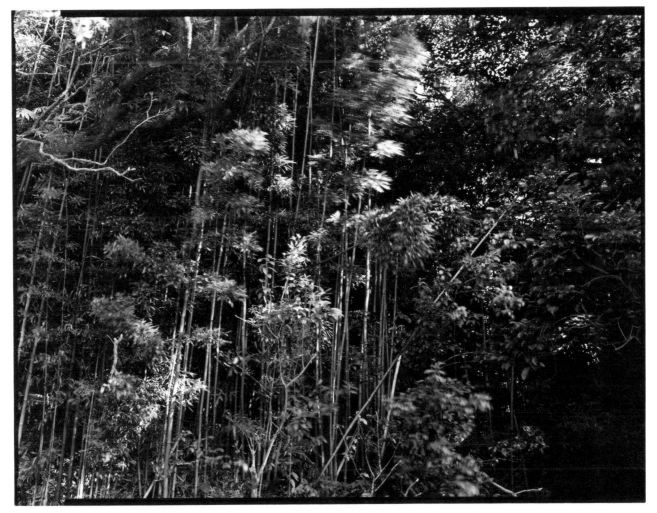

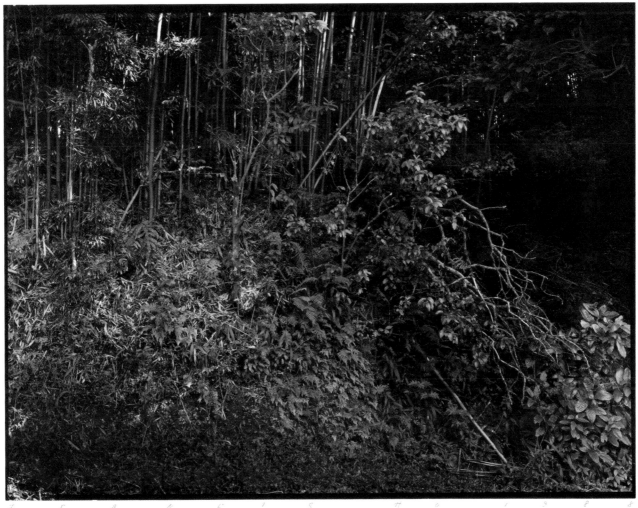

Pacific Coast Series #11: Bamboo trunks, Pali, 1989

"Predominating here is a mature trunk, yellowed from age; it is a very strong element standing against a dark background. I wanted to present it as a monumental figure, allowing motion around it to evoke the feeling of the wind."

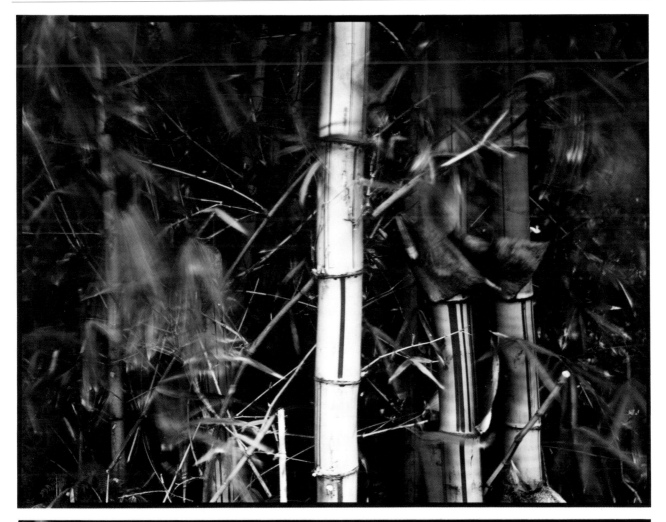

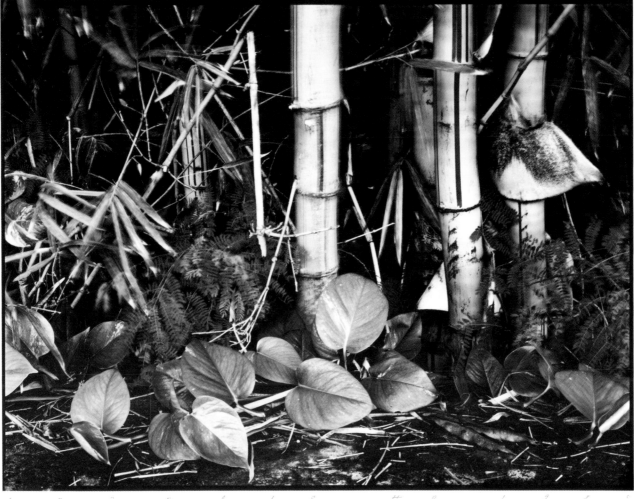

Pacific Coast Series #9: Koa tree and ginger, Kauai, 1989

"This image, taken on the island where my grandmother was born, has exceptional emotional meaning for me. The site is near a former family retreat—where a friend had a vacation place for several generations—of which I have many fond memories. Due to state regulations, the structure was dismantled. I shot this image as a kind of 'memento mori' to be put into his new retreat, built with parts of the original house.

"Here, the koa tree is dominant, with smaller forms subservient in a hierarchy of forms. I took the image in the failing light of late afternoon. Ritchie and Mary Gentry, who took my wife and I to this family site, were very patient with my time-consuming insistence on locating the 'right' spot to set the camera up."

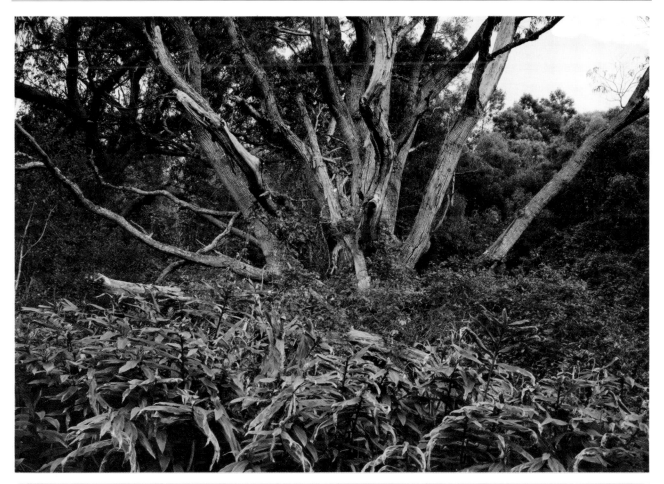

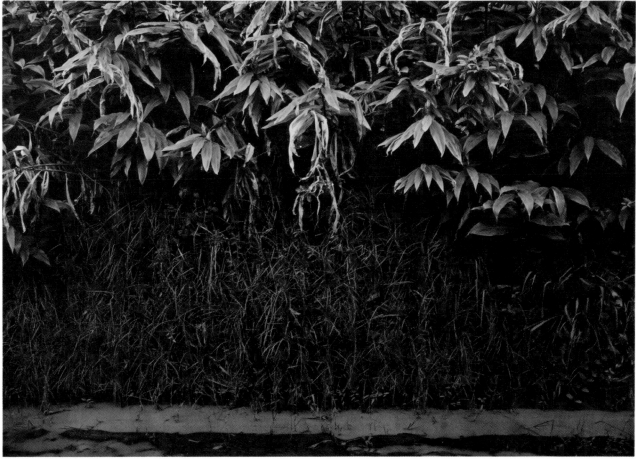

Pacific Coast Series #6: Pali, 1989

"Two centuries ago, the Pali on Honolulu was the place where King Kamehameha and his warriors won a final battle, completing the unification of the Hawaiian Islands. According to legend, Kamehameha's force pushed opposing warriors up the valley where I was raised, eventually driving the enemy army and its leaders over this cliff.

"When amongst the grandeur of mountains, we sometimes ignore whatever is directly in front of us. Here, I included discarded debris left by visitors. At other times, however, I may remove scattered trash or eliminate other distractions before shooting. Here I decided to include elements that have become an inescapable part of our environment."

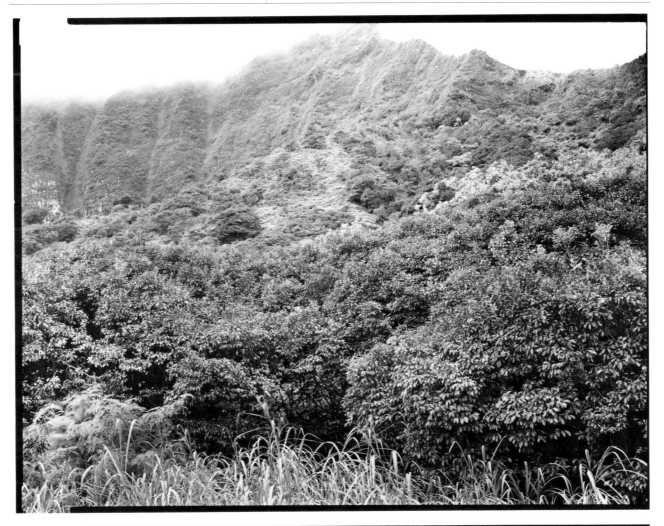

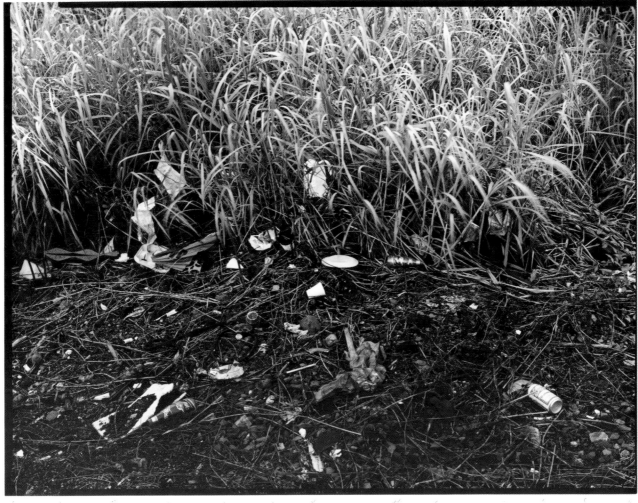

Pacific Coast Series #8: Banana grove, Kaneohe, 1989

"My 93-year-old grandmother, Elsie, lived near here in a nursing home. While taking her on a picnic outing, we stopped along the road for lunch, and it was then that I saw the banana grove and the mountain. My grandmother identified every species of banana tree for me.

"I made a composition as a reminder of this time we spent together. Again, the frame included discarded trash—an integral part of the scene. The central figure—the tree in front—is highly featured as in a portrait."

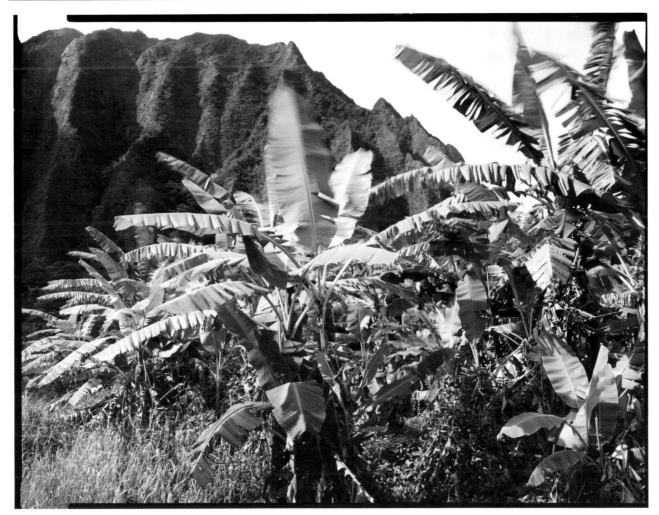

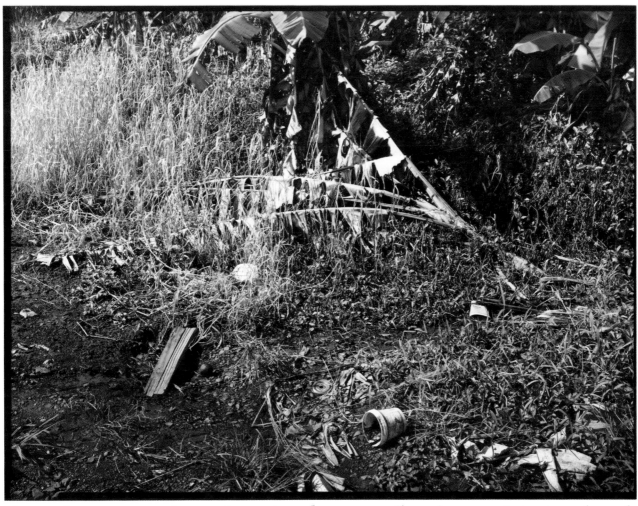

Pacific Coast Series #1: Koko Head, 1989

"I have a basic philosophy about using a large format camera and that is: 'Don't stray too far from the car.' Obviously, the camera is heavy and affects mobility. The photographs taken here, however, were an exception to my rule.

"I spotted and occupied the only vantage point for taking these images at the ocean's edge facing towards the mountain. It was a stormy day, with rain and strong winds. Waves lapped at the tripod, it fell, but, luckily, not over the edge. I reset the camera, and exposed all ten sheets of film from this spot. Here, the crashing white water contrasts against the sky and mountain. The darkened top edge is reminiscent of similar dark bands in traditional Japanese woodcuts. It provides another horizontal element, for added rhythm in the image."

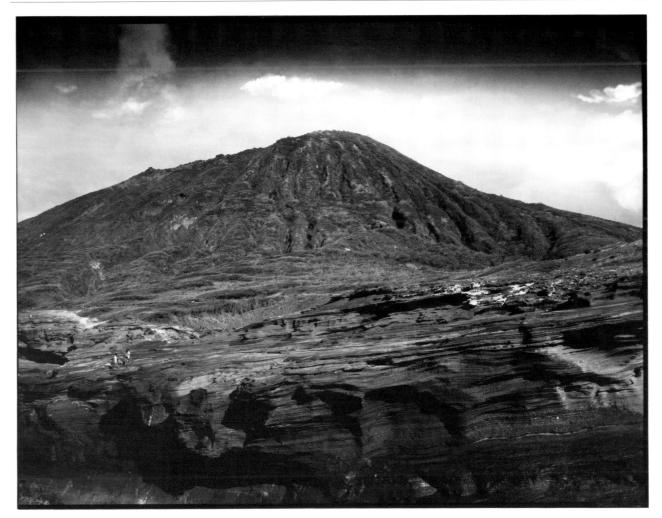

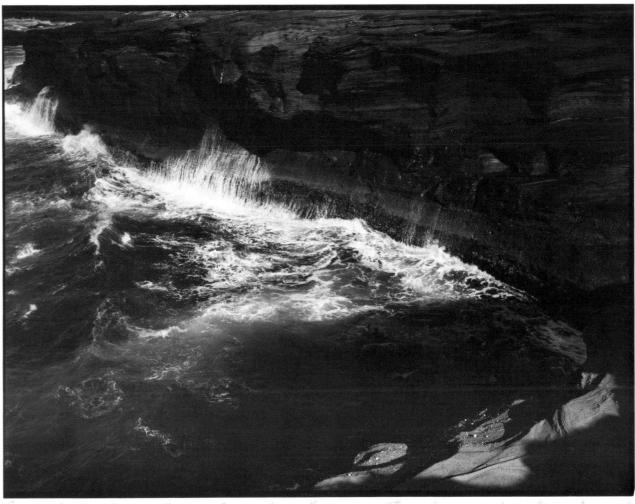

Pacific Coast Series #5: Lincoln City, Oregon, 1989

"I was fascinated with reflections in the pond. I wanted the foreground
to contrast with the detail above. Here, what seems simple actually is
complex, and what appears complex is simple."

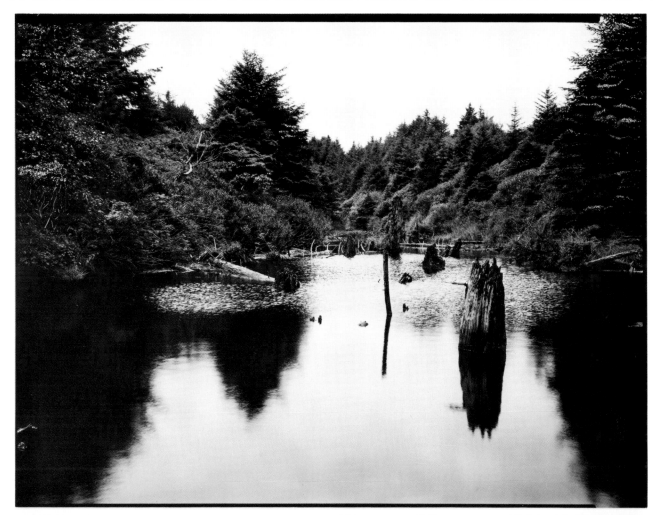

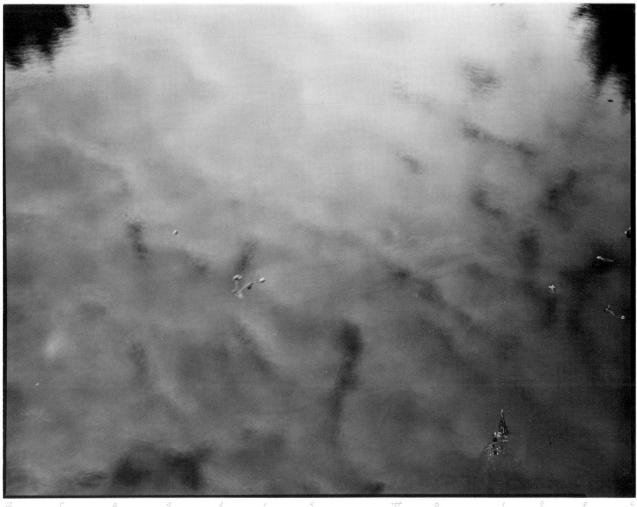

Pacific Coast Series #4: Northern California, 1989

"I spotted this beach while traveling on Highway 1. The rainy overcast conditions made me think a long time before finally deciding to haul the camera out. I set up to make separate compositions of the meandering stream and the pair of large rocks. During exposure, I placed the latter features at the edge of the image, creating a series of triangles that relate to each other.

"I ended up with a damp camera and gear that had to be hair-dryer blown dry that night in a humid, old, motel room."

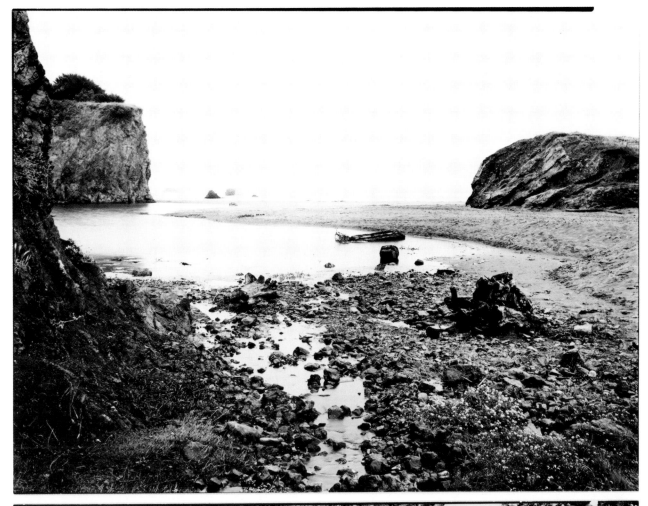

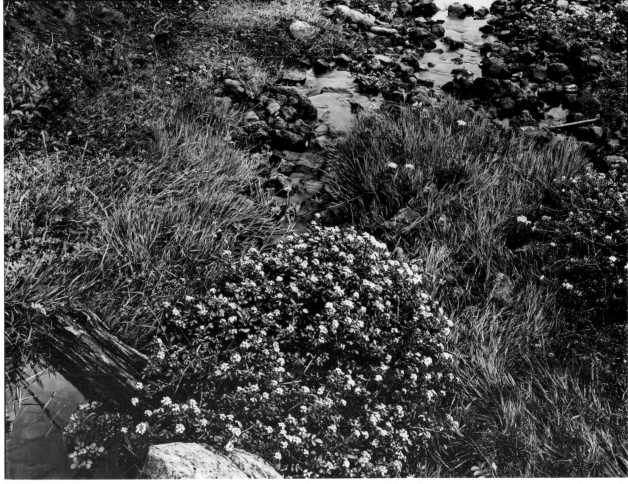

Pacific Coast Series #3: Fort Bragg, California, 1989

"Here, negative space is the center; I wanted the viewer to linger there. The negative space bonds the elements at the top and bottom. Waves roll in from the wake of a boat going by. I chose a slow shutter speed to capture motion in this calm haven."

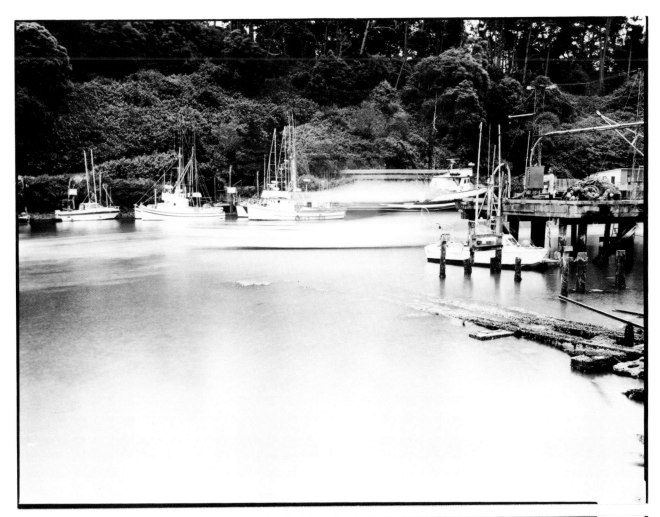

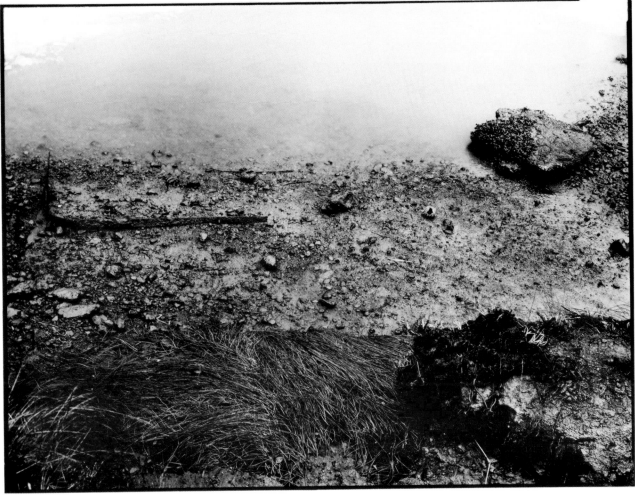

Pacific Coast Series #1: Fort Bragg Harbor, 1990

"Motion is introduced by the boat moving through the harbor.
The empty sky with the black edge at the top is similar to the
style of traditional Japanese prints."

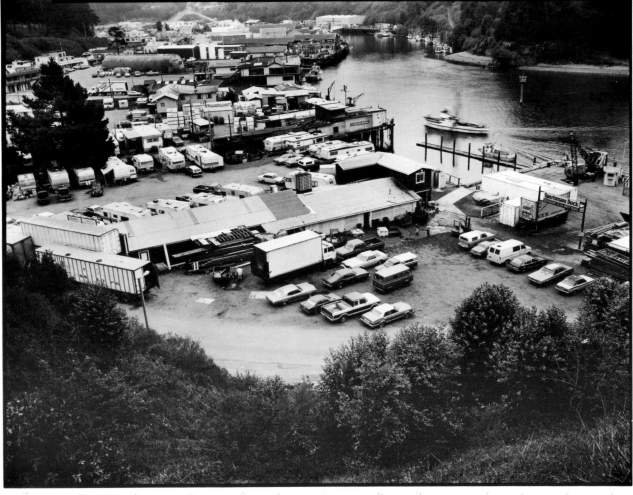

Pacific Coast Series #2: Fort Bragg, 1990

"The foreground provides a way for the viewer to enter into the composition. A heavy directional form also leads into the activity occurring in the upper image, where the boats are gathering. I used the land above to define the parameters of the forms and to balance the composition. I thought of Hiroshige, who frequently utilized a 'bird's eye' point of view in his woodprints; I was on a precipice, looking down on activity in the bay.

"Apparently, the Coast Guard was checking incoming vessels for drug smuggling. As the horns and megaphones blared, I felt that the entertainment was spectacular and I had the best seat in the house."

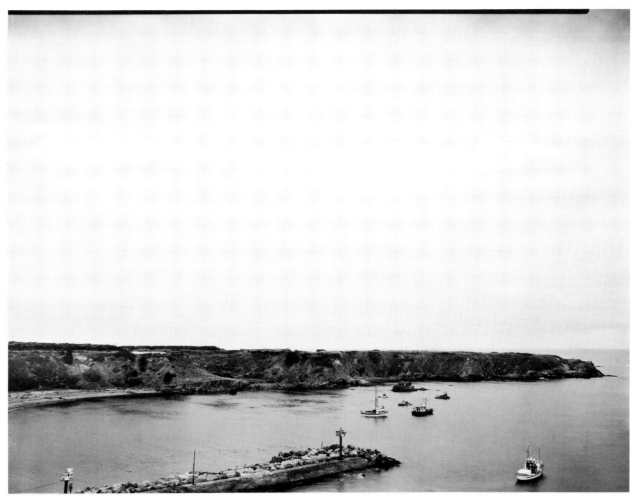

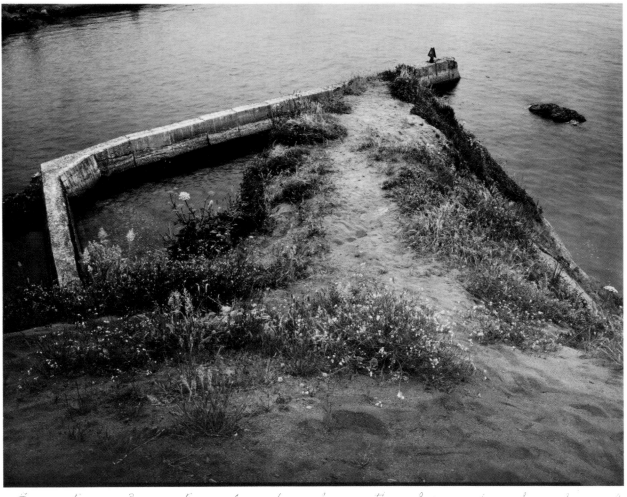

42

*Pacific Coast Series #5: Beach and Pacific Ocean,
Lincoln City, Oregon, 1990*

"Stilled movement, footprints, and patterns in the sand of this Oregon
beach make the eye travel all over. Yet, there are simple forms above."

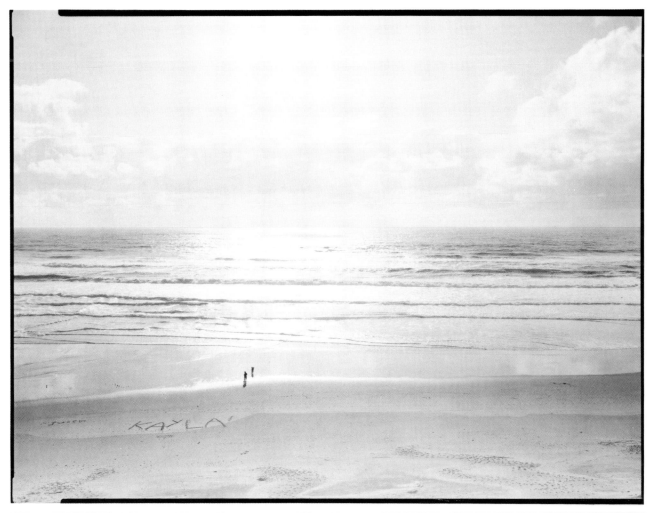

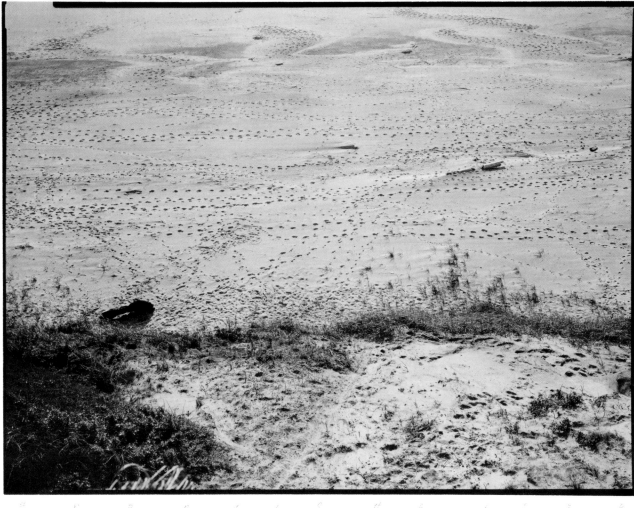

Pacific Coast Series #7: Grass and pines,
Siltcoos pond, Oregon, 1990

"Notice the reflections, and the radiance of the foreground
trees against the dark background. The overlapping
motion between the two images causes bonding."

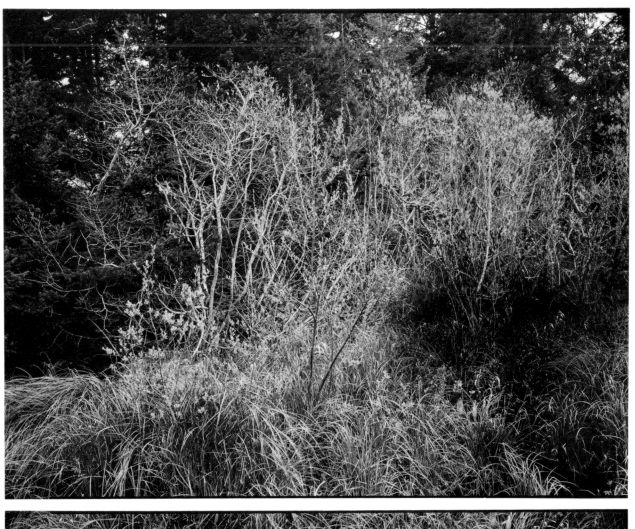

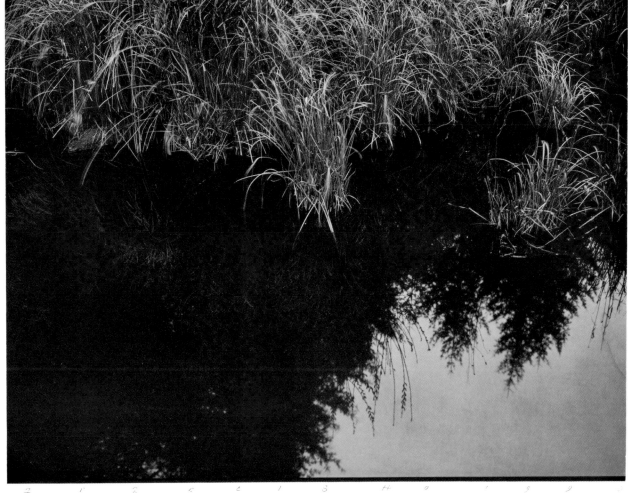

Moss and fern, Smith River, 1990

"While traveling on U.S. Route 101 from Carmel, I was struck by so many inviting areas along the meandering Smith River in northern California. I especially was drawn to the serenity of just being there. Before light failed in the evening, I pulled off the highway and walked along the river's bank until I found this scene. I set the tripod up in the strong current and it was nearly swept away. The weight of the camera and heavy rocks tied to the tripod's post allowed me to compose this piece."

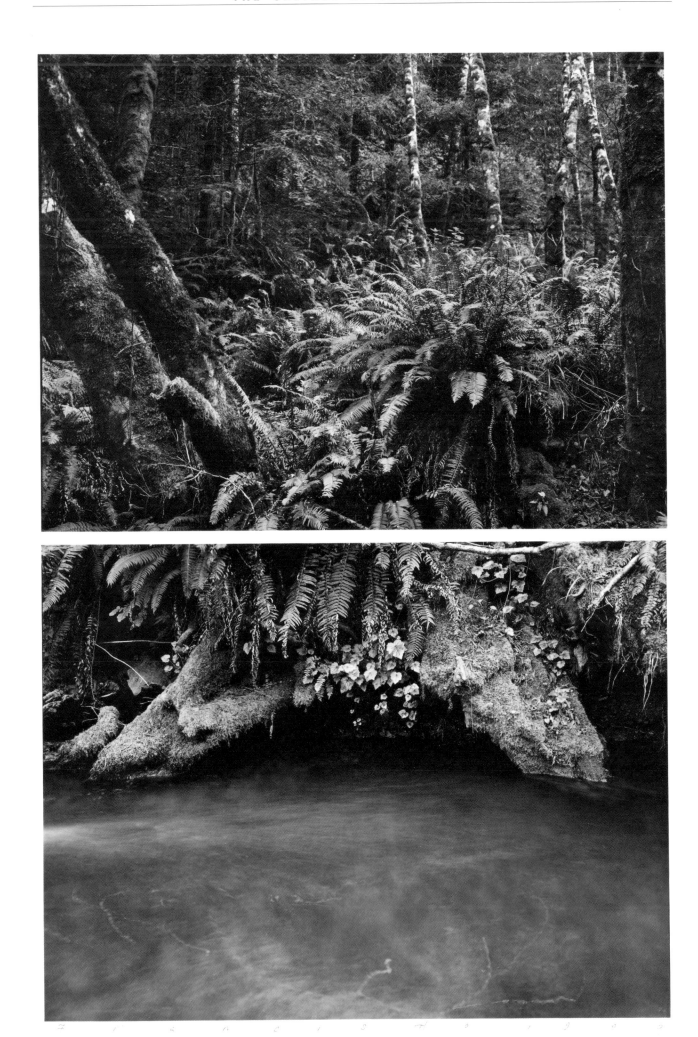

Corrugated metal and alder, Cape Perpetua, Oregon, 1990

"This composition is basically horizontal on the bottom, with vertical elements above serving as the subject matter. The amount of light on the tree trunks is equivalent to that on the drainpipe covered by foliage. I wanted to tie these two together within the composition."

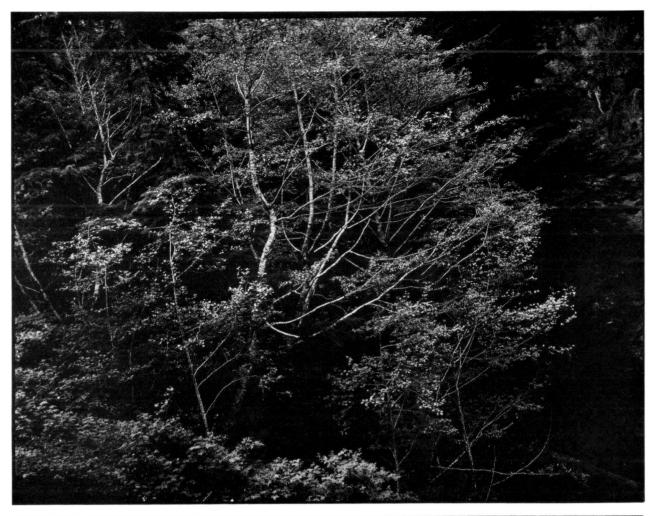

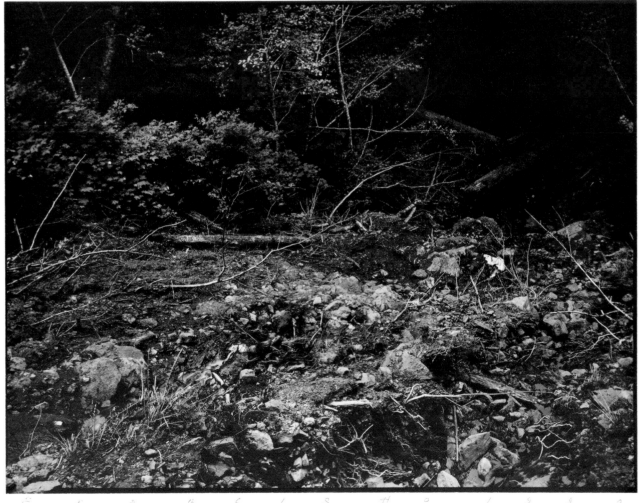

Ferns and alder, Cape Perpetua Road, 1990

"In this composition, with its strong quality of light, I fantasized in a child-like manner about sentinels standing in front of a battalion of brilliant armored knights. A triangulation composes the horizontals and verticals. I sought a balance in brilliance between the bottom and top forms."

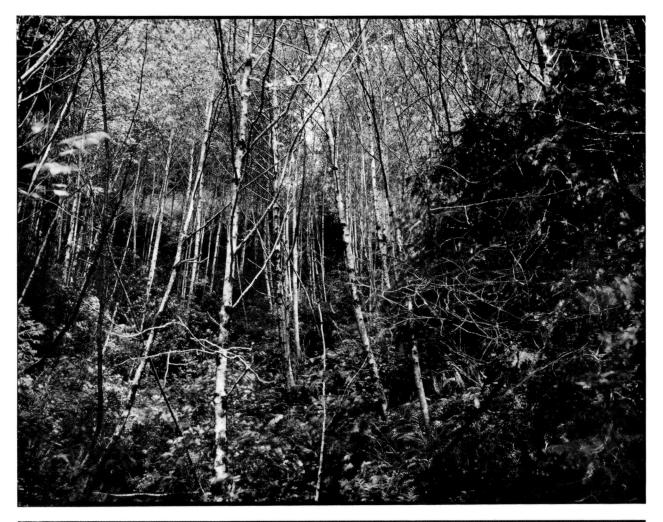

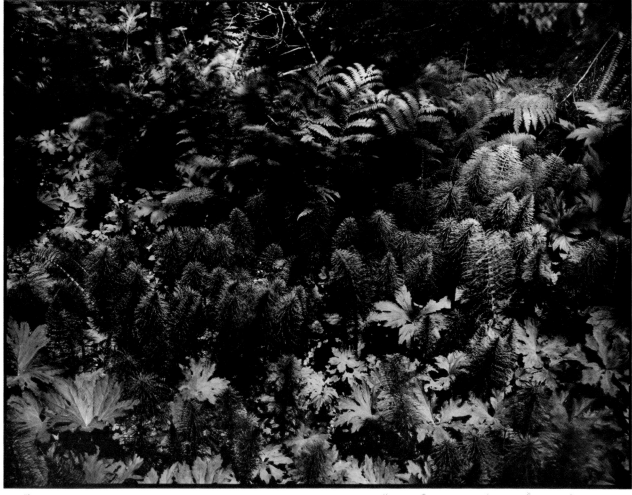

52

Ferns, maple, alder, and pine, Cape Perpetua Road, 1990

"The trees on the side create an angular pattern sweeping out to the right, which is picked up by other forms that are in motion. The primary figures likewise are flanked by the moving forms. I felt some electricity and tension in what was occurring here; the elements are matched, yet un-matched. I trust the eye to put this together as a whole."

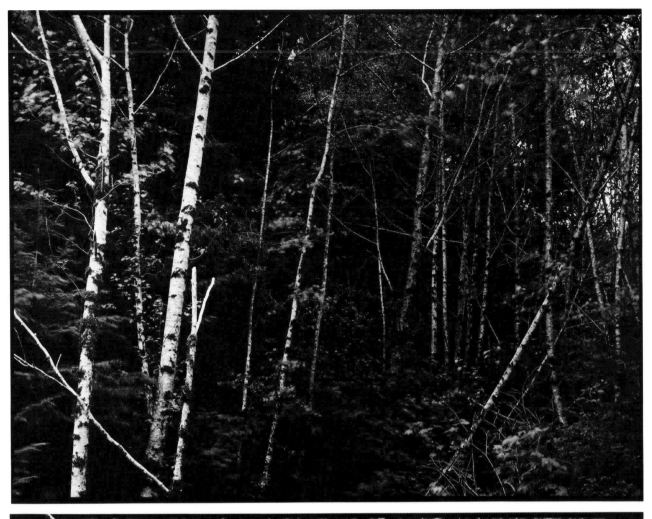

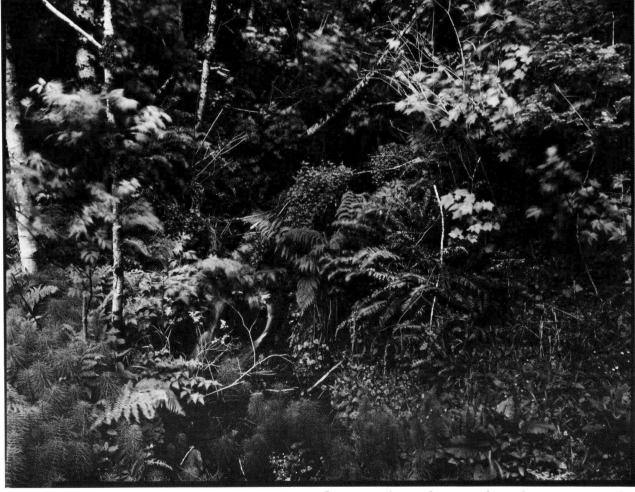

54

Corrugated drainage pipe, Millington, Oregon, 1990

"At first glance, the corrugated pipe might be mistaken for a rather large flaw on the print. I wanted to contrast this awkward form with the brilliant, delicate branches located above it. Both forms are in similar light."

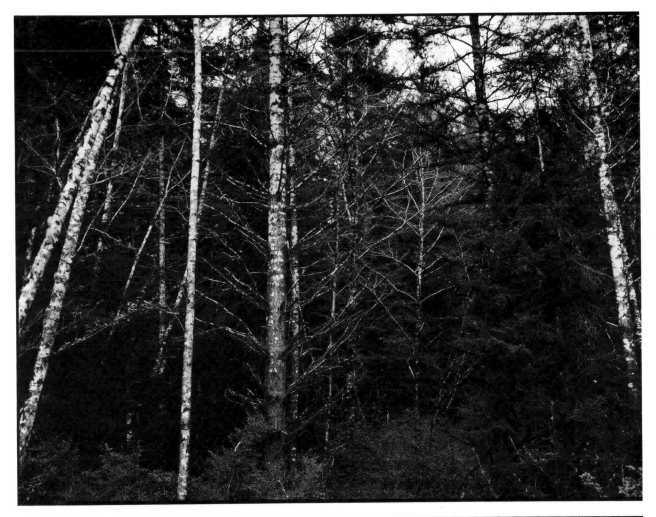

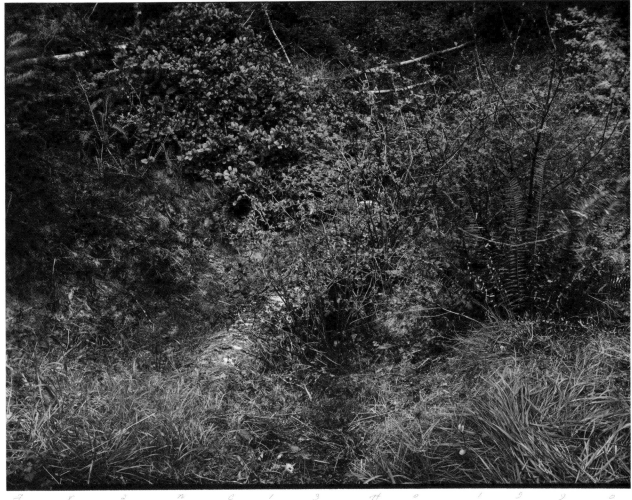

56

Pines, Lincoln City, 1990

"I must have passed by this area a dozen times in the course of
two days before I photographed it. I was drawn by the massive
dominance and symmetry caused by two pines, dramatized
even more so by the delicate foliage growing at the base."

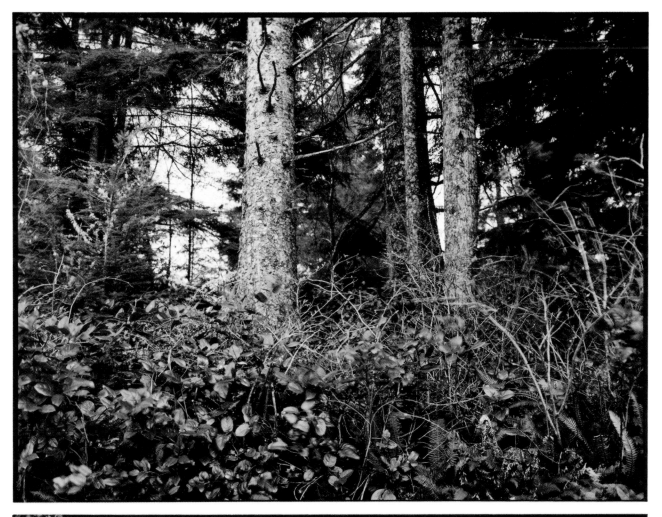

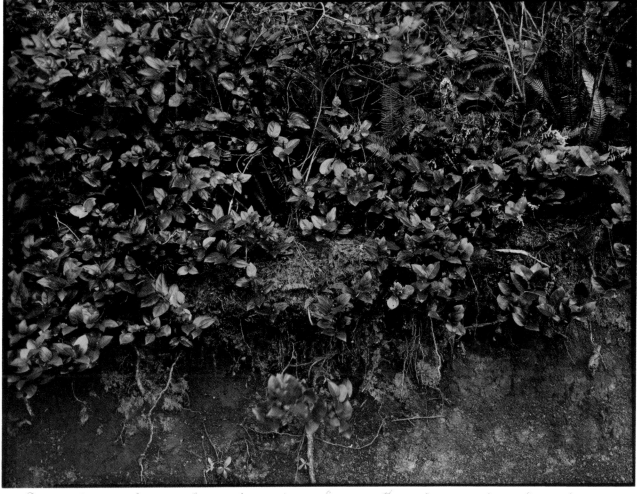

Jan and Buck, Middle Fork of the Clearwater River, 1990

"As the morning shafts of light sifted through the trees along this north Idaho stream, Jan and Buck enjoy the sun, slight breeze, the sound of slow flowing water, and being in the purity of nature. As with so many of my compositions over the years, they were waiting for me to take some exposures before breaking down the gear and moving on to another site. I decided to include them for scale in what I felt was a majestic scene."

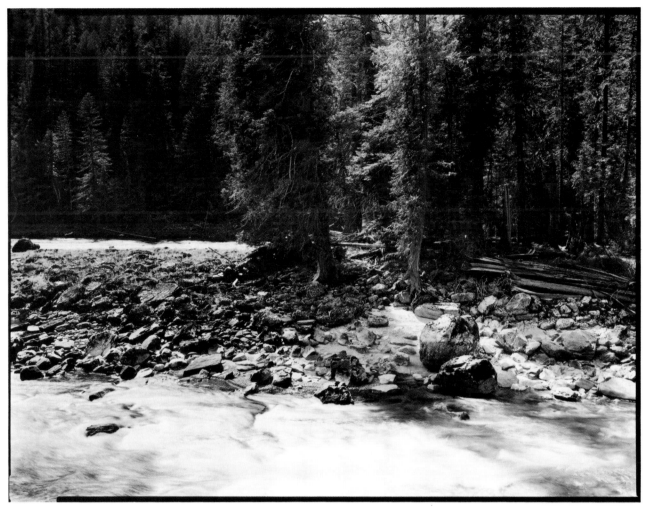

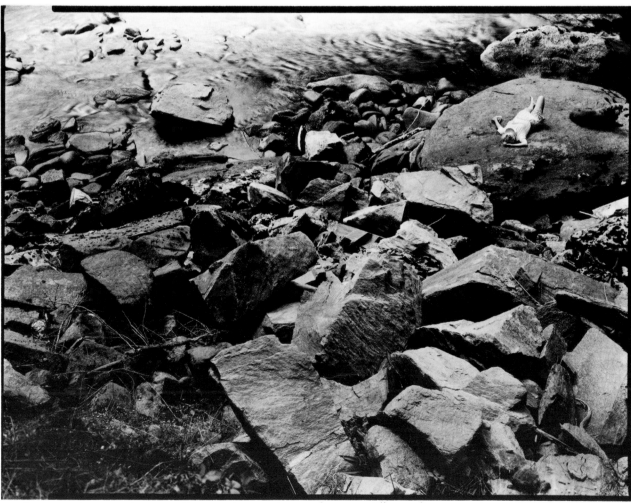

Selway Falls, 1990

"To make these images on Idaho's Selway River, I lowered my equipment down a steep precipice, and set up on a cliff with the tripod tied to a nearby rock. The 'point of view' is 'looking down' in the lower print, and 'looking up' in the top photo.

"A slow shutter speed captured the contrast between the rushing water and the rocks (motion vs. stationary). There is much detail here; however, the rock at the top is highlighted as a 'simple form' to define the content underneath it. The trees address the big rock, establishing a hierarchy of forms."

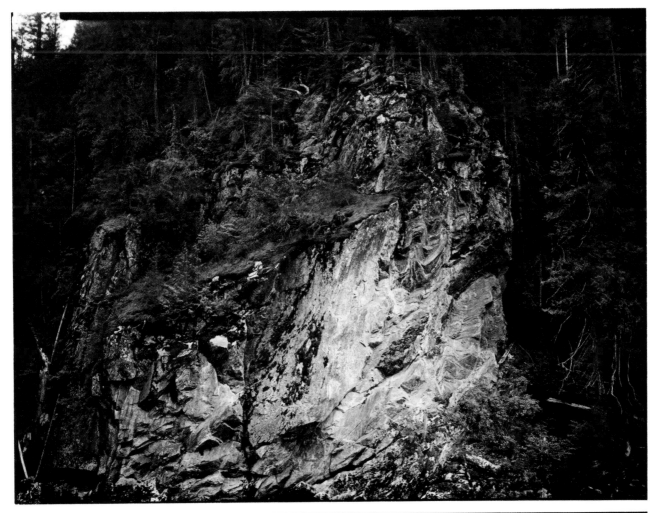

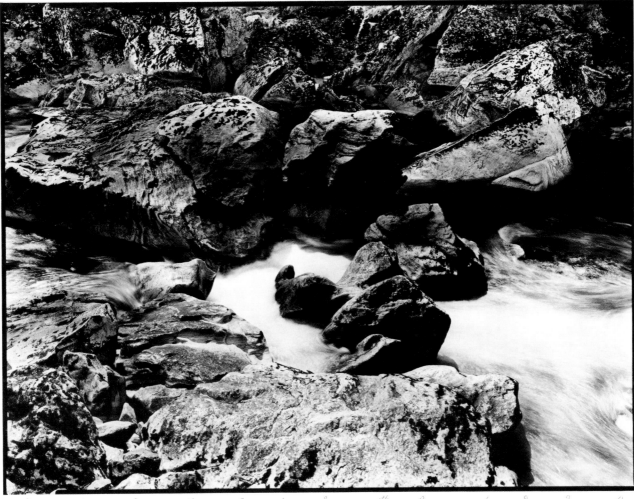

CHRONOLOGY/ BIOGRAPHY

Time Line

1938 Born in Honolulu, Hawaii.

1961 Bachelor of Fine Arts, Yale.

1962 Designer, I. M. Pei Architectural Associates, New York.

Began two-year stint as U. S. Army Lieutenant in Korea, Japan, and the U.S., retiring as reserve Captain five years after completing active duty.

1964 Began three years of professional work at Adkins and Merrill Industrial Design (Sudbury, MA), Robert Wright Design, and Abe Josephson, Photographer, (Rochester, NY) while attending graduate school.

1967 Master of Fine Arts, Rochester Institute of Technology.

Began long-term career as professor of Photography and Graphic Design in the Department of Fine Arts, Washington State University, Pullman, while concurrently participating in 21 one person and 45 group exhibitions in the United States, Europe, and Japan.

1969 Silver Purchase Award, Nikon Camera Company, New York. Repeat award in 1973.

1974 Original release of photography art book, *Hose Valley*, by the Art Directors Club of Los Angeles. An expanded version published a year later by Drukkerij Rosbeek, Holland. Photographic work represented by Canon Photo Gallery, Amsterdam.

1975 Award of Excellence, 16th annual exhibition, *Communication Arts* magazine; Art Merit Award, 13th annual Western advertising art exhibition, Art Directors Club of Los Angeles; Certificate of Excellence, American Institute of Graphic Arts; and the One Show Merit Award, Art Directors Club of New York.

1977 Using 8 X 10 inch view camera.

1979 In September, began serving six months as exchange professor at Nihon University, Tokyo.

1982 Completed two-year stint as Director, Asian American Studies Program, Washington State University, Pullman.

1983-86 Summer instructor, Victor School photography workshops, Victor, Colorado.

1984 Working exclusively in 11 X 14 inch format.

1988 Photographs represented by The Silver Image Gallery, Seattle, Washington.

1991 *Dualities* exhibitions:

The Photographic Center of Monterey Peninsula, Carmel, California.

Honolulu Academy of Arts, Honolulu.

One Person Exhibitions

1966 Rochester Institute of Technology, Rochester, New York.

1970 The Gallery, Pullman, Washington.

Gallery II, "The Guggenheim," Washington State University, Pullman.

1971 Museum of Art, Washington State University, Pullman.

1972 Infinity Gallery, Seattle.

1973 Wall Street Gallery, Spokane, Washington.

Magic Lantern Photo Center, Rohnert Park, California.

Focus Gallery, San Francisco.

University of Idaho, Moscow.

1977 Canon Photo Gallery, London.

Canon Photo Gallery, Amsterdam.

Canon Photo Gallery, St. Gallen, Switzerland.

1978 Open Mondays Gallery, Seattle.

1979 College of Art, Nihon University, Tokyo.

1980 Photo Gallery International, Tokyo.

Gallery 16, Lewis and Clark State College, Lewiston, Idaho.

1984 Design Council (Photographs), Portland, Oregon.

1988 St. James Episcopal Church, Pullman.

1989 Denison University, Granville, Ohio.

1991 The Photographic Center of Monterey Peninsula, Carmel, California.

Honolulu Academy of Arts, Honolulu.

Public Collections

Canon Photo Gallery, Amsterdam.

City of Seattle Portable Art Collection, Seattle.

International Center of Photography, New York.

Museum of Modern Art, New York.

Nikon Camera Company, New York.

Photo Gallery International, Tokyo.

Washington State University (Holland Library),
 Pullman.

Yale University (Beinecke Rare Book Library),
 New Haven, Connecticut.

Selected Publications and Articles

CA 75: The 16th Communication Arts Annual. Palo
 Alto, 1975.

Colombo, Attilio. *Fantastic Photographs.* New York
 and London: Random House and Gordon Fraser,
 1979.

Cordoni, David. "The Oriental Eye." *Artweek,*
 May 26, 1973.

"Francis Ho: The Gestalt of Human Perception."
 Universe [WSU Graduate School], Winter 1989.

Ginjaar, Aloys. "Francis Ho." *Foto* [Amsterdam],
 January 1977.

Ho, Francis. *Hose Valley.* Los Angeles: Art Directors
 Club of Los Angeles, 1974.

_____. *Hose Valley.* Hoensbroek, Holland:
 Drukkerij Rosbeek, 1975.

"The One Show." *The 54th New York Art Directors
 Club Annual.* Watson/Guptill, 1975.

Sawamoto, Tokumi. "Francis Ho." *Camera Mainichi*
 [Tokyo], February 1980.

Yoshikawa, Yaomi. "Francis Ho." *Commercial Photo*
 [Tokyo], April 1980.

CREDITS

WSU Press
Office of University Publications and Printing
Production Photographer: Robert Hubner
Designer: David C. Hoyt
Editor: Glen Lindeman